GREAT WORKS OF
NAIVE ART

Doreen Ehrlich

A Compilation of Works from the
BRIDGEMAN ART LIBRARY

PARRAGON

Naive Art

This edition first published in 1996 by
Parragon Book Service Ltd
Units 13-17 Avonbridge Industrial Estate
Atlantic Road
Avonmouth
Bristol BS11 9QD

ISBN 0 75251 171 8

Printed in Italy

Editors: Barbara Horn, Alexa Stace, Alison Stace, Tucker Slingsby Ltd and
Jennifer Warner.
Designers: Robert Mathias and Helen Mathias
Picture Research: Kathy Lockley

The publishers would like to thank Joanna Hartley at the
Bridgeman Art Library for her invaluable help.

NAIVE ART

The life and work of the naive artist is distinguished by several characteristics whether the painter comes from America, Great Britain or Eastern Europe and was born at the end of the 18th century or in the 20th century. Unlike academically trained artists, naive painters probably fitted in their painting while working at something else. Henri Rousseau, for example, worked at a customs post until he retired to paint full time, and Grandma Moses and Helen Bradley devoted their lives to their families and the domestic domain before starting to paint in their old age.

Most naive painters come from relatively modest backgrounds, and only rarely have they had much formal education, which explains the inscriptions on the works themselves – as in the case of *The Peaceable Kingdom* by Edward Hicks and *Admiral Lord Exmouth* by an unknown artist – and the fact that many works are not signed or dated. The work these artists produce is sometimes known as folk art because it is produced by and for ordinary people, and is tied to the needs, ideas and culture, in its widest sense, of those people. In this most important respect it is radically different from what might be called its high art counterpart, which is produced by professional artists for a relatively small market of wealthy buyers. It would not, however, be true to say that all naive or folk artists were, or are, necessarily untrained in their painting skills.

In most naive painters a lack of formal education is matched by an inner vision that is recognizably their own. It is the characteristic ability to communicate clearly and simply with straightforward imagery that knows no national boundaries that makes the appeal of naive painting so immediate. These artists often also use whatever material is available, which is why, for many works, it is impossible to say now with certainty what medium was used.

There are certain other characteristic factors, such as the uninhibited use of clear colour and the lack of modelling and chiaroscuro that link the work of naive painters. In some works there is a desire to represent an ideal world, a world of childhood perhaps, remembered in an idyllic manner. This idyll can also be set in a dream world where Old Testament prophecies may come true. On the other hand it is not unusual for naive artists to represent the here and now.

In American folk art the work of itinerant painters is closely tied up with the needs of the client group, people of the same social stratum as the artist, who needed records of themselves and particularly, in an age of high infant mortality, of their children. The universal desire to perpetuate a likeness meant that handmade portraiture for display in the family home was much in demand in 19th century America until the coming of photography in the 1860s made family likenesses easily available, considerably more accurate and undoubtedly inexpensive.

In 19th century Britain, where the aspiring artist in the high art field was trained in the exacting skills demanded by the Royal Academy, his naive counterpart probably worked as a sign or coach painter. When occasion demanded, this artist, skilled in his particular field, could be commissioned to make a visual record of a special event or perpetuate the likeness of a particularly fine farm animal, painted in profile, with an attendant to give scale.

In the 20th century artists in both America and Europe were not commissioned to paint what was placed in front of them but painted of their own volition, portraying, with the clarity that is characteristic of the vivid memories of childhood, a lost world very different from that in which they found themselves, one that existed in their mind's eye.

The naive artists of Eastern Europe, particularly the Croatians Ivan Generalic, Mirko Virius and Ivan Rabuzin. Generalic and other artists established a national identity by exhibiting together in Zagreb before the Second World War. The official public recognition and status accorded to these painters since then is matched by the huge popular appeal of such artists' work both in the original and in reproduction.

Less familiar in reproduction abroad but of huge national importance is the work of the 20th century artists of Haiti. The extraordinary richness of Haitian folk art is deeply rooted in the culture and beliefs of the people, and is central to their lives. In Port au Prince, for example, the murals on the walls of Holy Trinity Cathedral afford a highly significant public status to the folk artist that is rare in other countries.

Since its rediscovery earlier this century, naive art has reached a wide and growing public, responsive to the fact that such forms are a rich and vital part of each country's national heritage.

▷ **Portrait of a Girl in Red Dress** Ammi Phillips (1788-1865)

Oil on canvas

AMMI PHILLIPS was one of the most prolific portrait painters of his day. He worked for most of his long life in western Connecticut, Massachusetts and the neighbouring counties of upstate New York. As an itinerant painter Phillips had to ensure client satisfaction, and the reasons for his successful career and large body of work can be seen in this striking portrait, with its closely observed detail of dress and domestic setting. The small girl is shown in a red dress with red beads around her neck and the family pet for company. The same or similar dress and beads appear in at least one other portrait known to be by Phillips, of a different girl holding the family cat. As in the portraits by the English 18th century painter Arthur Devis, who often painted different women in the identical dress and room setting, it is possible that the dress represents an ideal rather than reality.

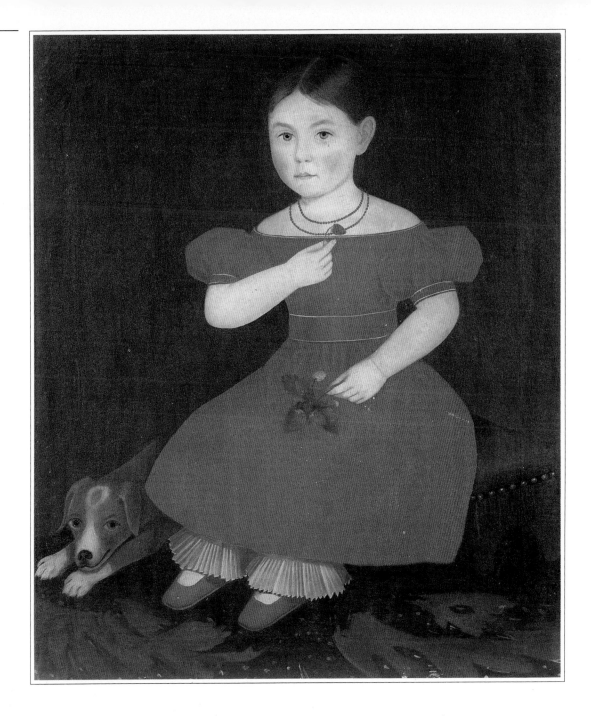

▷ **The Peaceable Kingdom** Edward Hicks (1780-1849)

Oil on canvas

THE MOST CELEBRATED American folk painter of religious and historical pictures, Edward Hicks is best known for his *Peaceable Kingdom* paintings. Hicks takes as his text the prophecy of Isaiah: 'The wolf also shall dwell with the lamb and a little child shall lead them' (11.6-9). The seated lion, which is so often a prominent part of Hicks' paintings of this subject, is frequently shown with grain stalks in its mouth, a further representation of the prophecy in Isaiah that in the peaceable kingdom the lion will renounce its carnivorous nature and instead of eating flesh 'shall eat straw like the ox'. The two animals are often placed in close proximity . In some versions of the *Peaceable Kingdom*, and some 60 versions of the subject by Hicks are known, William Penn's treaty with the Indians, an event of particular significance for Pennsylvanian Quakers, is represented in the distance, as in this example.

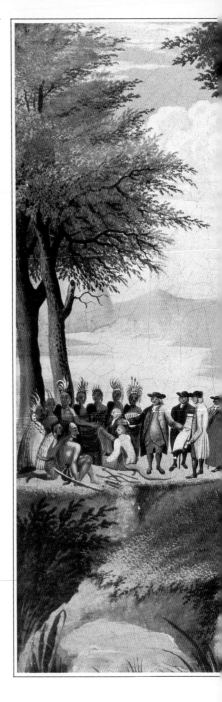

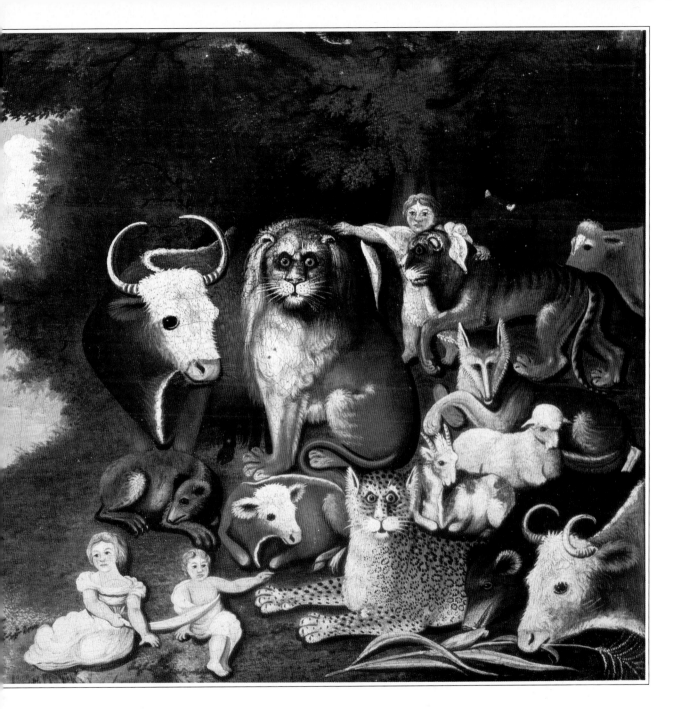

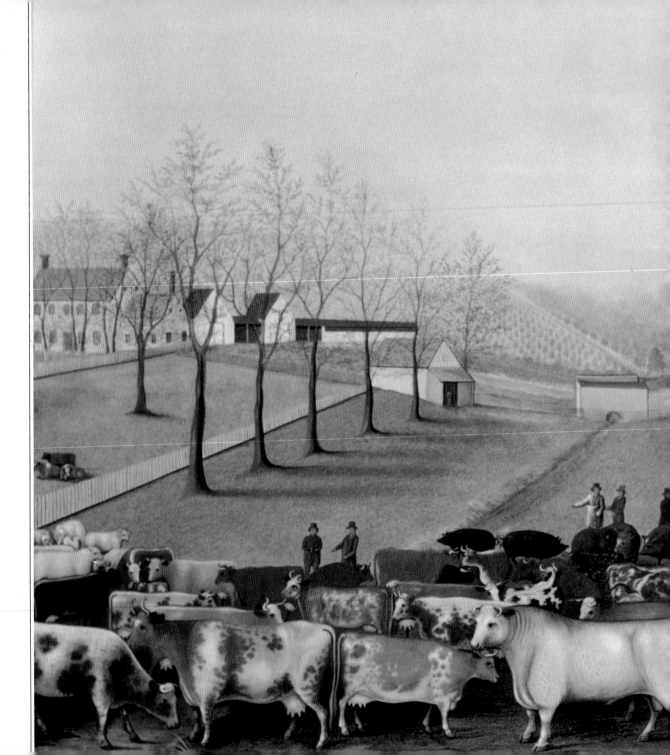

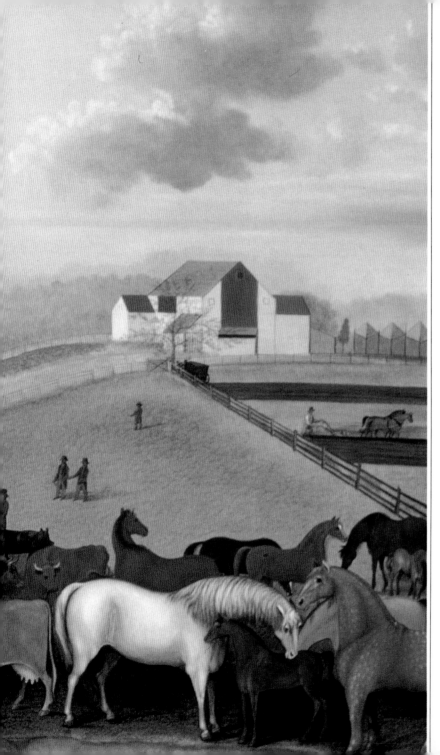

◁ The Cornell Farm
Edward Hicks

Oil on canvas

HICKS WAS A CARRIAGE PAINTER by trade and in his lifetime was well known as a Quaker minister. His easel paintings of religious and landscape subjects, for which he is so celebrated today, must certainly represent only a tiny proportion of his work as an artisan, as the bulk of his everyday work has disappeared. He produced several paintings on commission from friends and neighbours of their Bucks County farms and prize animals. This example is generally considered to be the finest painting of Hicks' mature period. Each of the farm animals ranged in the foreground of the panoramic view is represented with its separate identity and specific markings in a peaceful, celebratory scene, comparable in spirit and in the skill with which it is painted to the *Peaceable Kingdom* paintings.

▷ **The Grave of William Penn**
Edward Hicks

Oil on canvas

EDWARD HICKS called himself
'but a poor old worthless
insignificant painter', but now
he is one of the best known
and loved of all folk painters in
the history of the art. In this
painting he takes as his subject
an imaginary view of the grave
of America's best known
Quaker, William Penn. Penn's
treaty with the Indians formed
the subject of no less than 13
canvases by Hicks and is
sometimes shown as a detail in
his *Peaceable Kingdom*
paintings. Hicks appears to
have associated Penn and his
treaty with the fulfilment of
the prophecy of the biblical
peaceable kingdom on Earth
as related in the Book of
Isaiah. The event had
particular significance for
Pennsylvania Quakers, such as
Hicks. This painting is
inscribed with the legend
'Grave of William Penn at
Jordans in England with a
view of the old Meeting House
and Grange Yard and J. J.
Gurney with some Friends
looking at the Grave'.

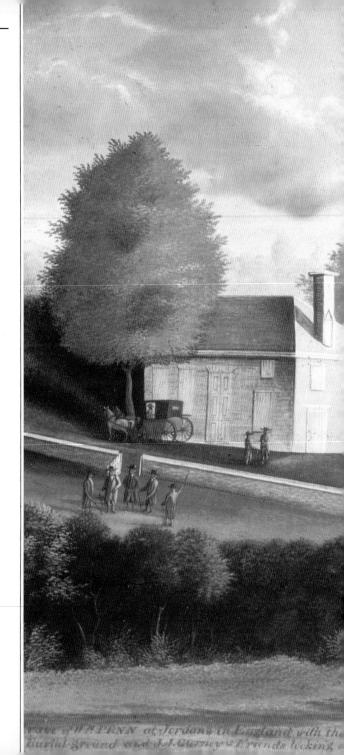

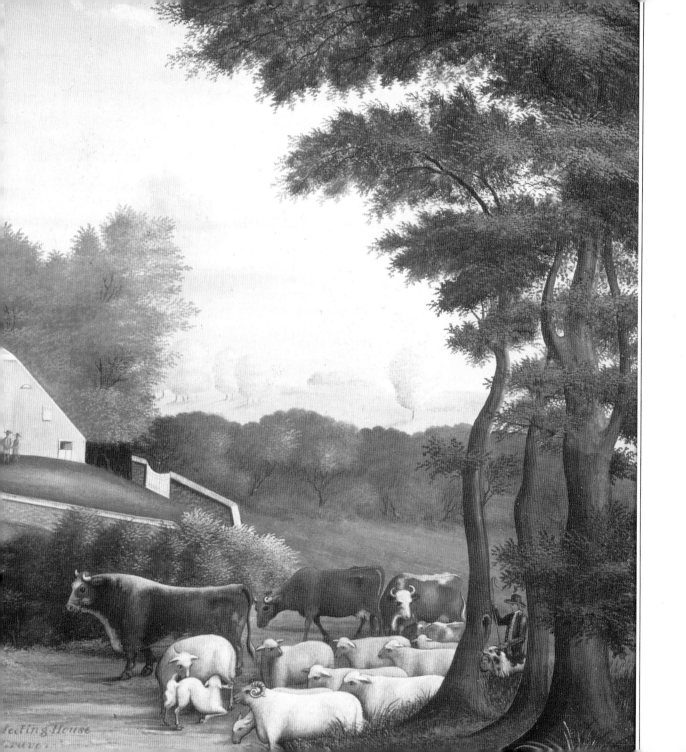

feeTing House
Grave:

▷ **Mourning picture** c.1800-10 Artist unknown

Silk, ink and watercolour on silk

MOURNING PICTURES were very popular in the United States in the early years of the 19th century. They were painted for friends and family, and often developed variations on a range of standard motifs considered appropriate at that time, such as classical urns and weeping willows, which also appear on funeral monuments. The techniques of painting such works were widely taught in learning establishments for girls and were more commonly produced in urban areas where women had more time for such genteel leisure activities. Such hand-painted mourning pictures remained popular in America until the 1840s, when the development of new print techniques, particularly that of lithography, made serially produced images inexpensive and available to a wide public. The frame of this fine example of the genre is inscribed 'Lucretia Carew, 1800'.

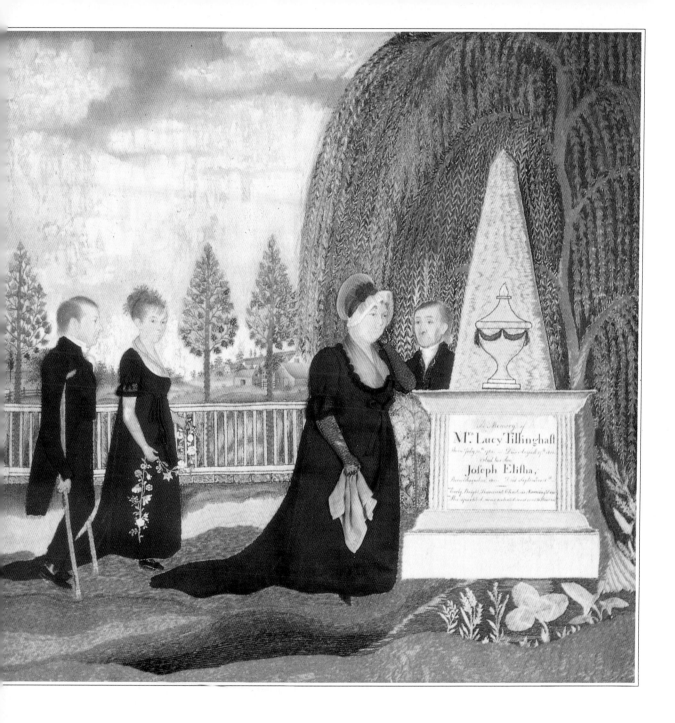

▷ **The Ark of the Covenant**
Erastus Salisbury Field
(1805-1910)

Oil on canvas

ERASTUS SALISBURY FIELD
spent the earlier part of his
extraordinarily long life as an
itinerant painter, travelling the
Connecticut River valley and
working solely as a portrait
painter. With the greater
availability of inexpensive
photographic likenesses as the
century progressed, demand
for painted portraits declined
and Field began to turn to
religious subjects, which
photography could not rival.
This painting, with the biblical
subject of the Israelites
receiving the Ark of the
Covenant back from the
Philistines, is typical of the
works produced in his latter
years. The motif here is
developed from an earlier
19th century engraving, as was
Field's custom. When Field
died, at the age of 95, his
obituary commended him as
'an all round painter of the old
school...his likenesses of
people of past generations are
as nearly correct as can well be
made in oil.'

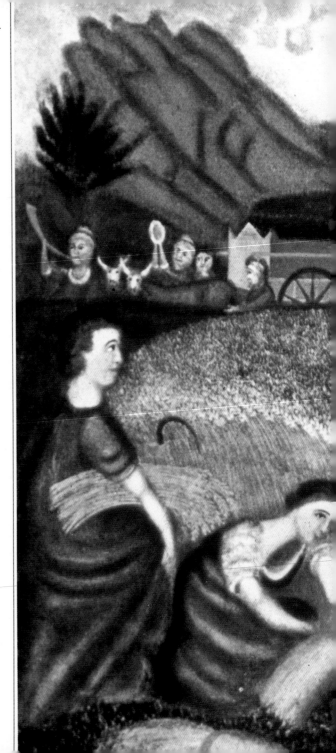

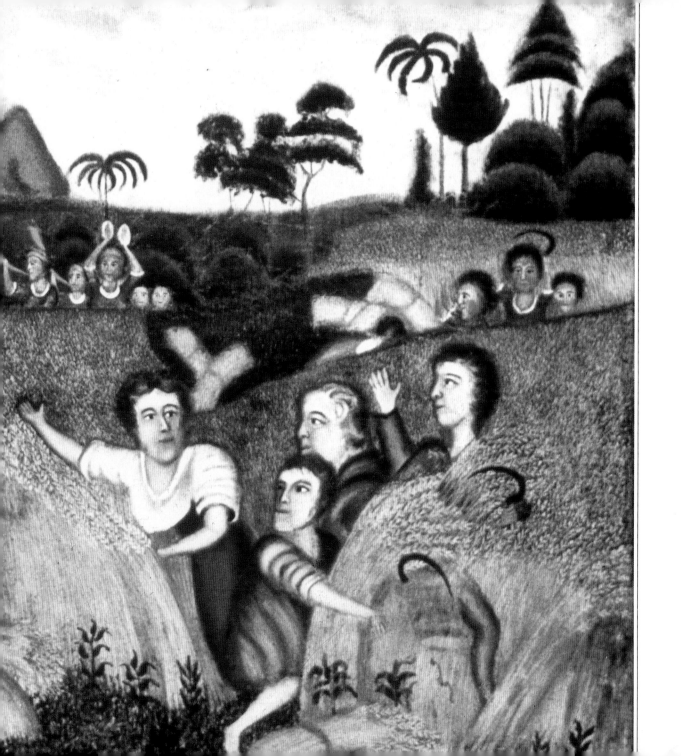

▷ **Gathering to Thresh the Flax** c.1850s
Linton Park (1826-1906)

Oil on mattress ticking

THIS PAINTING shows the ritual celebrations attending the threshing, or 'scutching', of flax for linen in Pennsylvania, where the artist Linton Park specialized in painting such genre subjects as this, farm scenes and scenes from the lives of loggers. The long, frieze-like arrangement of the figures at the flax-scutching bee, as it is sometimes known, is seen against a background of farm buildings, including a log house with a stone chimney on the left. The whole scene is one of lively and humorous incident. The figures on the right are all working hard while those on the left appear to have abandoned work. The historical importance of this painting and its humorous portrayal of such community activity make it uniquely popular in American folk art.

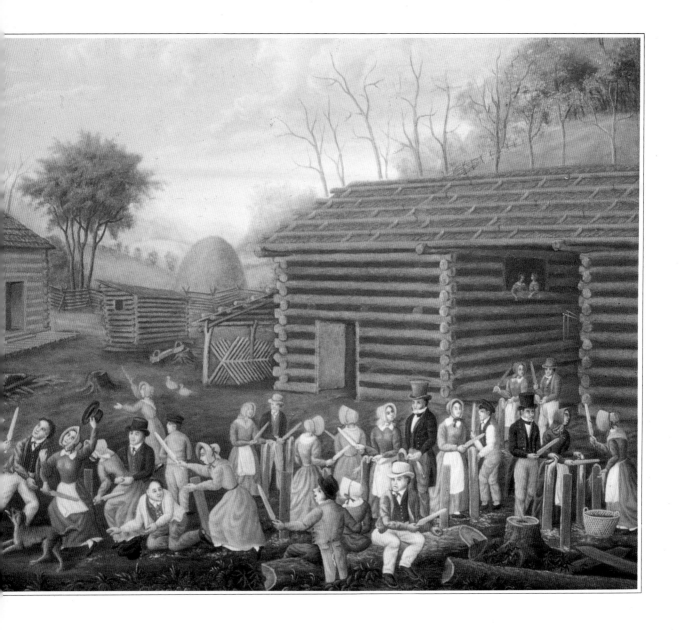

▷ **Bareback Riders** 1886
W. H. Brown

Oil on board mounted
on wood

VERY LITTLE IS KNOWN about
the painter, W. H. Brown,
apart from the fact that he was
painting during the 1880s and
that he worked in and around
the state of Michigan. This
painting, one of only four
known by the artist, is signed
and dated. In this remarkable
work Brown has attempted to
convey the magic of a
particularly exciting moment
at the circus, with the
performers presented in close-
up and the audience relegated
to impressionistic and
anonymous blobs, apart from a
couple shown in sharper focus
behind the ringmaster. The
static ringmaster and clown act
as foils to the seemingly
impossible feat of the bareback
riders, who, in their splendid
costumes, are frozen in
graceful movement on the
back of the magnificent
galloping black horse.

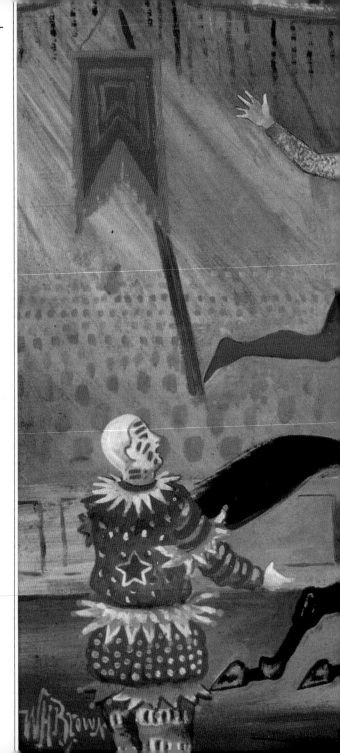

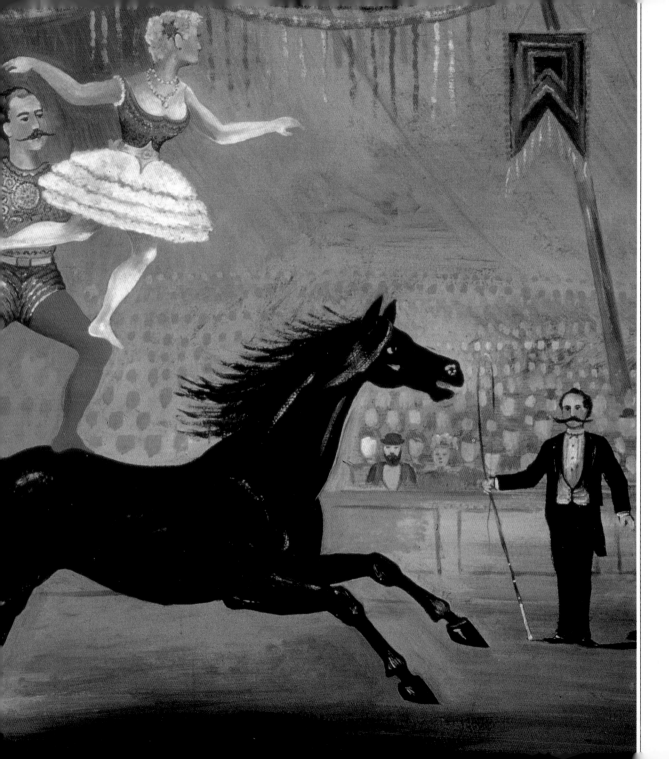

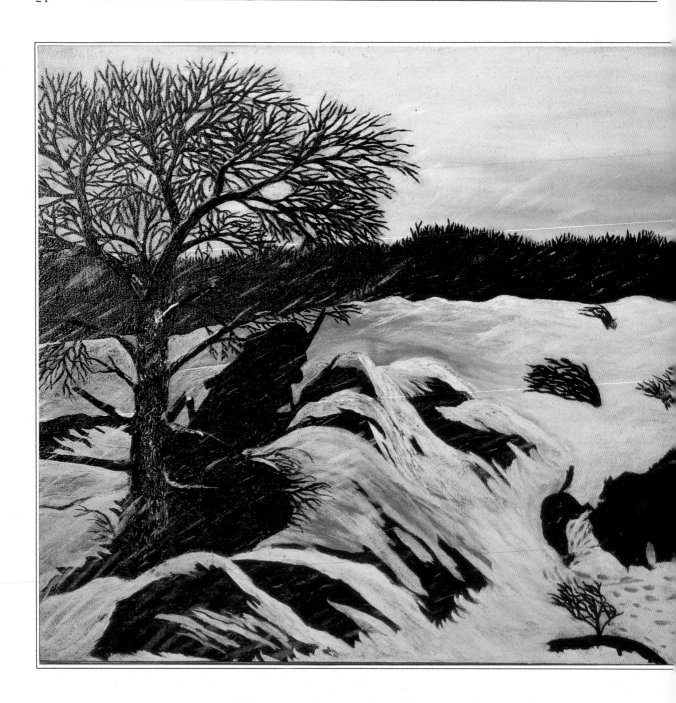

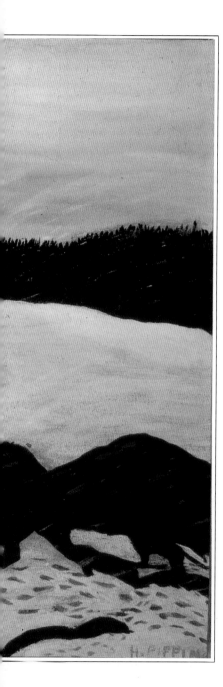

◁ **The Buffalo Hunt**
Horace Pippin (1886-1946)

HORACE PIPPIN is the most remarkable black American naive artist of his time. Born in West Chester, Pennsylvania, he moved to New Jersey in 1911, enlisting in the army in 1917, when the United States entered the First World War. During the fighting in France Pippin was so badly wounded that his right arm was paralyzed. When he first began to draw again, on his return to the United States, he developed exercises to strengthen his disabled arm, and in 1929 began to use paints. Asked about his method of work, Pippin explained, 'I go over the picture in my mind several times and when I am ready to paint it I have all the details that I need.' Pippin was deeply affected by the horrors of the war, and in this monochrome painting the savagery of a buffalo hunt in a bleak landscape is given powerful expression.

Holy Mountain II
Horace Pippin

▷ *Overleaf page 26*

SELF-TAUGHT AS A PAINTER, Pippin explores themes in his art that had deep personal significance. His experience as a soldier on the Western Front in the First World War profoundly affected his life and work, and he appears to have treated scenes of both everyday life and historical themes from a personal perspective and in such a direct manner as to convey his own experience. He was also deeply religious. *Holy Mountain*, a theme to which Pippin returned no less than four times, in some respects is reminiscent of Hicks's *Peaceable Kingdom* paintings. The representation of the 'Good Shepherd' figure and of the children playing among the wild animals is particularly interesting and characteristic of Pippin's religious paintings.

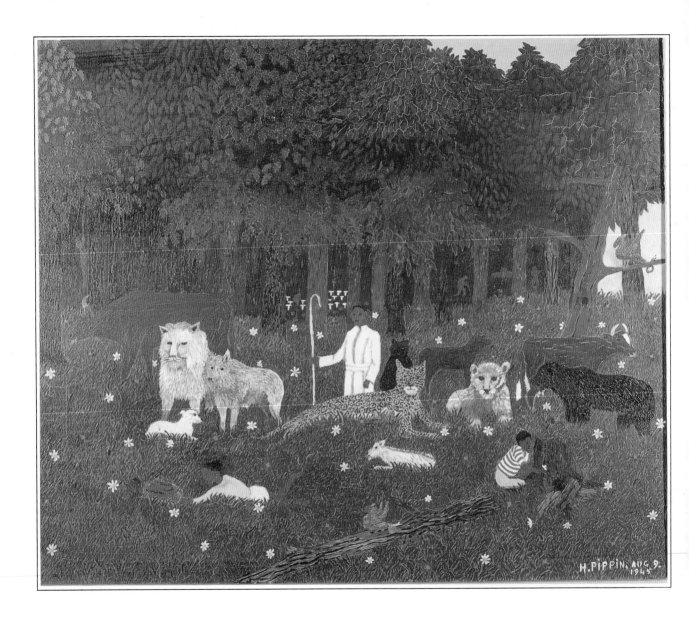

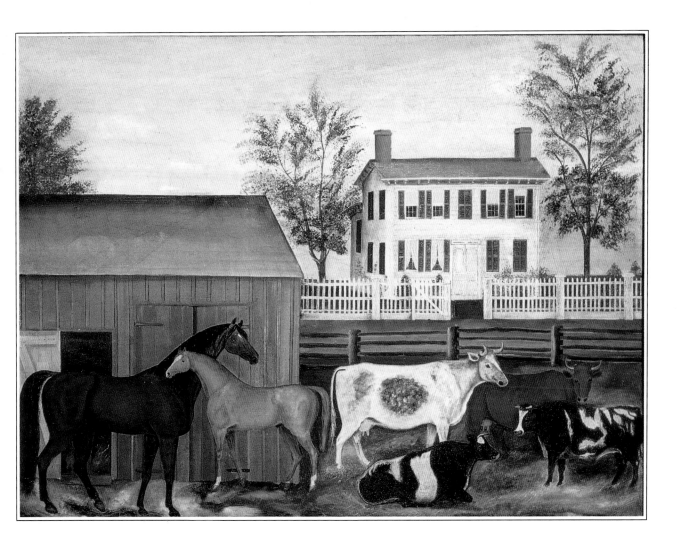

▷ **Hoosick Falls, N.Y. in Winter** Grandma Moses (1860-1961)
Copyright © 1995, Grandma Moses Properties Co., New York

Oil on masonite

GRANDMA MOSES (Ann Mary Robertson Moses) is certainly the best known and probably the best loved of all 20th century American naive painters. She began to paint only in her 60s, when she became less able to perform her strenuous domestic duties because of arthritis. After the death of her husband in 1927, Grandma Moses moved from the farm they had run in the Shenandoah Valley in Virginia, and where they had brought up the five surviving children of the ten born to her. Back in New York State, where she had been born, she began to display her paintings with the jams and jellies at local fairs. Then, in 1938, she began to exhibit in a local drugstore window. Grandma Moses' first one-woman show was held when she was 80. She is perhaps most famous for her landscapes, which are often, as in the two paintings reproduced here, peaceful winter scenes crowded with telling incidents.

The Barnyard Amsi Emmons Zeliff (1831-1915)

Oil on canvas

◁ *Previous page 27*

THIS IS THE ONLY known painting by Amsi Emmons Zeliff, an American painter of Dutch descent. Zeliff worked as a painter in New Jersey and this fine painting may be regarded as a type of farm portrait, comparable to Edward Hicks's earlier *The Cornell Farm* (page 13). However, whereas Hicks and other painters of similar subjects provide a panoramic view of the farm, with the prize-winning stock ranged in the foreground, Zeliff produces a close-up view of the horses and cattle in a bold and elegant horizontal composition of animals, shed and house. Such details as the irregularity of the raised blinds and the open and closed shutters of the house are in striking contrast to the flat, frieze-like forms of the animals in the foreground.

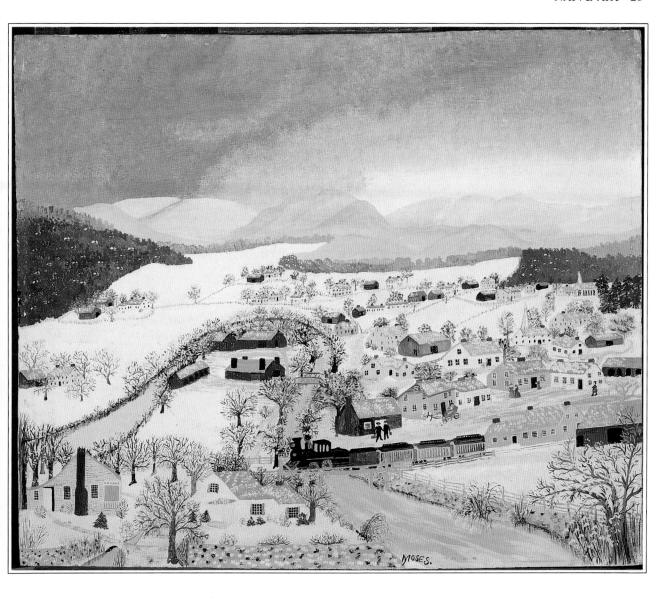

▷ **Out for Christmas Trees** 1946 Grandma Moses

Oil on masonite

GRANDMA MOSES achieved her greatest fame with winter landscapes such as this one. The bold and complex composition is painted in bright clear colours with a predominance of white and deep green. As with most scenes painted by the artist, the picture evokes the lost rural world of Grandma Moses' youth, and the bustle of activity involved in the arrival and departure of the horse-drawn sleighs shows a mastery of observation of human beings and animals typical of the artist's work. The comparatively small size of the figures enables the viewer to take in the panoramic landscape while simultaneously being able to concentrate on such a typically telling detail as that of the small boy standing facing the viewer in the near distance beside a fir tree no larger than himself. The boy appears to be both inviting the viewer into the picture and weighing the possibility of having the tree for himself.

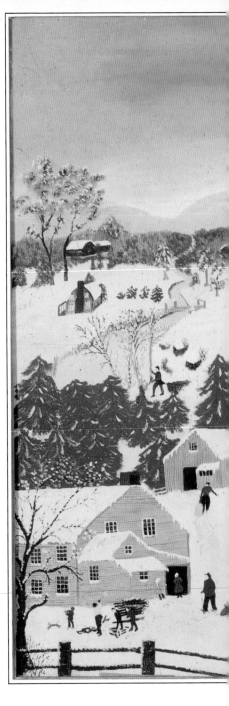

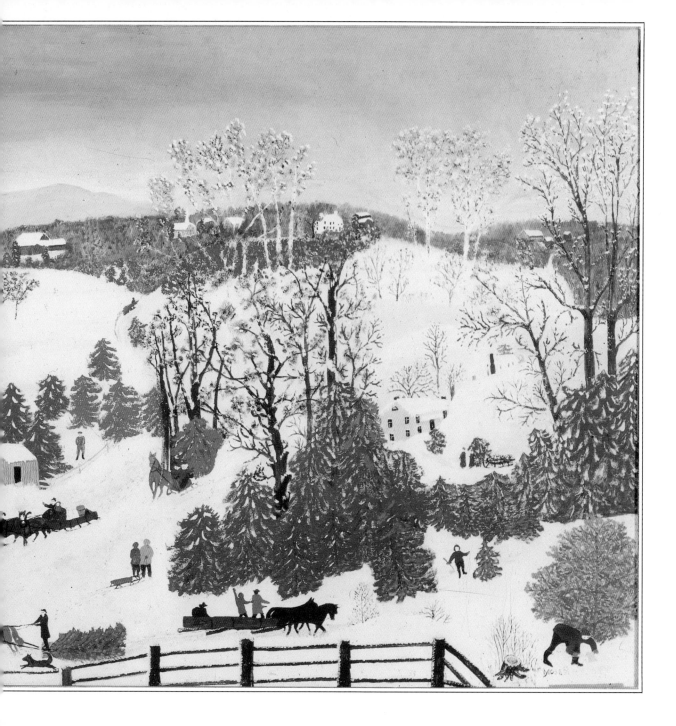

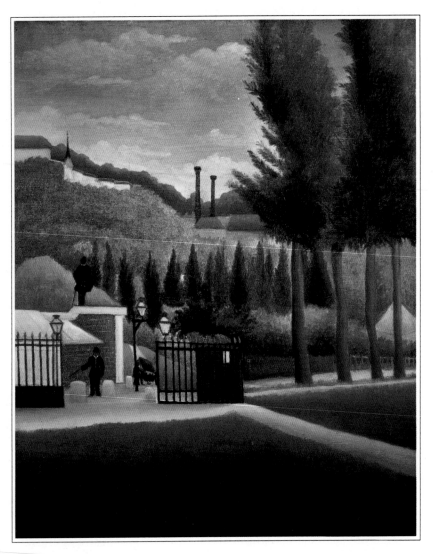

◁ **The Customs Post** c.1909
Henri Rousseau (1844-1910)

Oil on canvas

HENRI ROUSSEAU is the most celebrated of all naive artists and the only one whose work is shown alongside the works of such Paris contemporaries as Pablo Picasso (1881-1973) and Paul Gauguin (1848-1903) in museums throughout the world. His nickname *Le Douanier* makes reference to his job at the Paris Customs Office between 1871 and 1893, although he never attained the rank of Customs Officer *(douanier)*. Having worked for 40 years, he took early retirement to pursue his hobby of painting, which hitherto he had been able to indulge in only as a 'Sunday painter'. This canvas shows one of the customs posts at the gates of Paris, at which Rousseau himself may have worked.

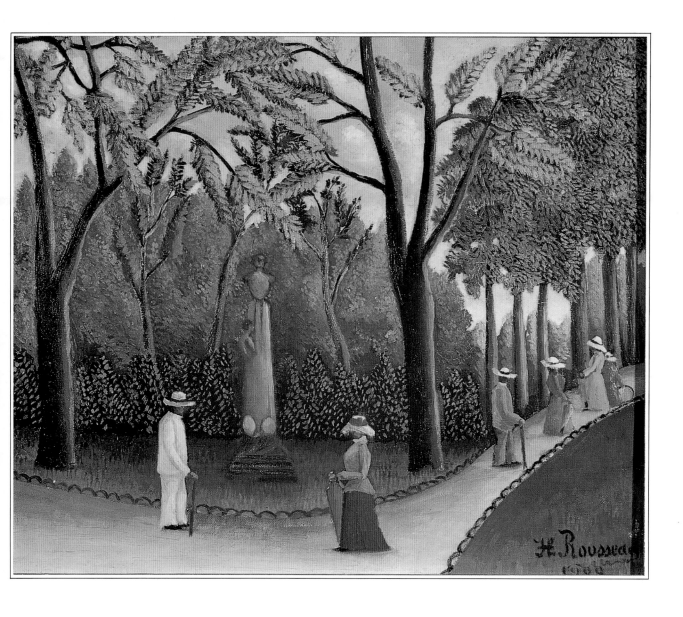

**Luxembourg Gardens,
Monument to Chopin** 1909
Henri Rousseau

Oil on canvas

◁ *Previous page 33*

IN THIS PAINTING Rousseau
represents the fashionable
Jardin du Luxembourg in
Paris, with elegantly dressed
strollers in a scene of high
summer. The formal gardens
act as a foil to the meeting (or
perhaps passing) of the man
and woman in the foreground,
against a typical Rousseau
setting of lush greenery. On
seeing Rousseau's work, the
painter Auguste Renoir (1841-
1919) remarked, 'It's curious
how disconcerted people are
when they confront the
qualities of a true painter.
The *douanier* Rousseau must
exasperate them above all
others!... Is it necessary to
understand what it means?'

▷ **Moi-même, portrait paysage
(Myself, Portrait Landscape)** 1890
Henri Rousseau

Oil on canvas

IN THIS SELF PORTRAIT
Rousseau depicts himself as a
giant figure against a busy
background of town and
country while above floats a
hot air balloon. Rousseau, to
whom affairs of the heart were
always important, has
inscribed the names of both of
his wives on his palette:
'Clemence et Josephine!'

A man of extraordinarily
ingenuous character, whose
faith in his own remarkable
powers remained unaffected
by the poor circumstances of
his life, Rousseau was
befriended by the avant-garde:
Picasso and other major artists
and writers of the time gave a
famous banquet in his honour
in 1908.

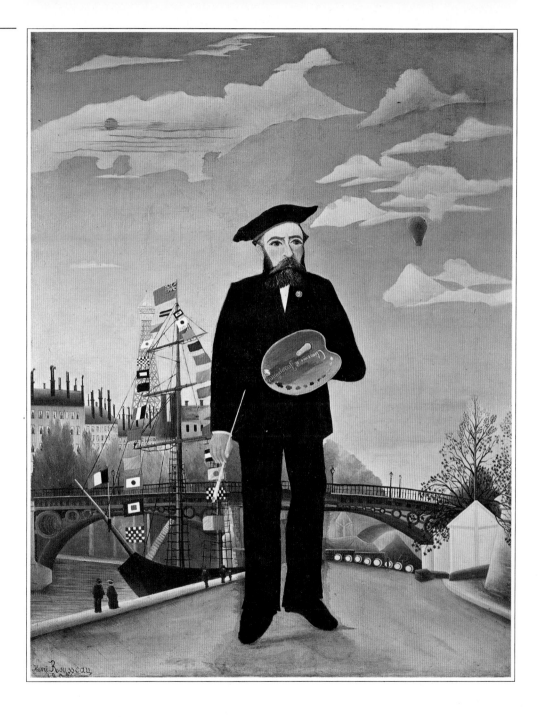

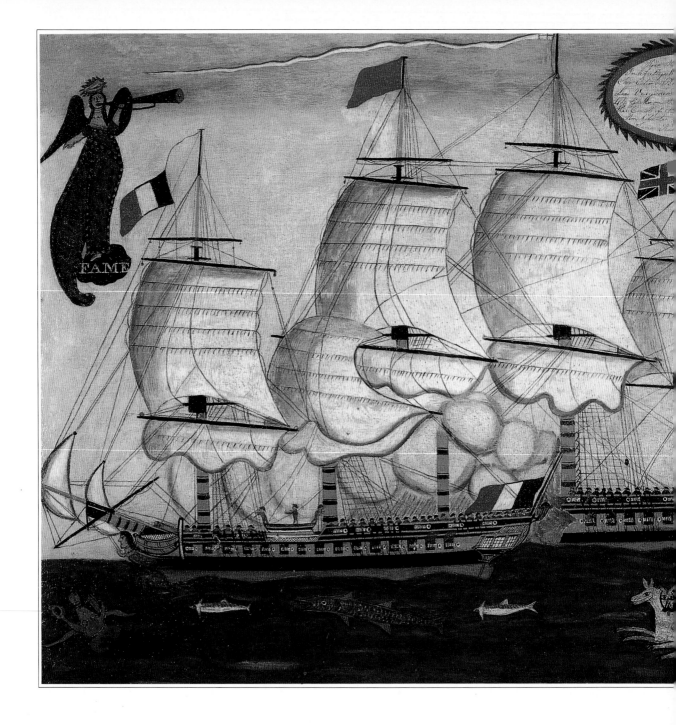

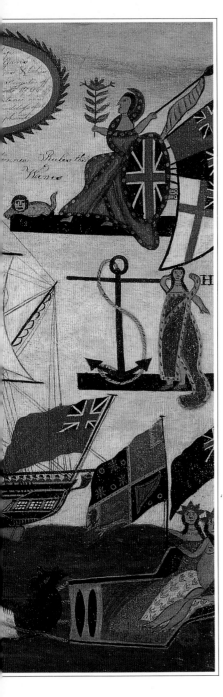

◁ **The Indefatigable** 1800 Artist unknown

Oil on canvas

THE EXPLANATORY inscription in the oval above the representation of the ships reads: 'His Majesty's ship *Indefatigable* of 40 guns Sir Edward Pellew engages and takes *La Verginia* a French Frigate of 44 guns on 22nd of April 1796 off the coast of France. Neptune and Amphitrite, god and goddess of the Seas Riding Triumphant.' To the right of this inscription Britannia is shown ruling the waves and beneath her is the figure of Hope with a huge anchor. To the left of the scene flies the figure of Fame with her trumpet, celebrating the famous victory. The commander of the *Indefatigable*, Sir Edward Pellew, was rewarded for this and other victories by being created first Viscount Exmouth in 1814.

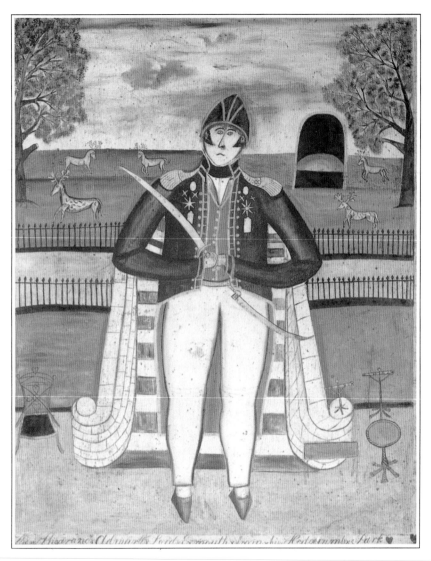

◁ **Admiral Lord Exmouth**
c.1815 Artist unknown

Oil, pencil and wash on paper

THIS PORTRAIT of the former Edward Pellew is inscribed along the bottom 'The Apearance of Admarll Lord Exmouth from his Hedgecumb Park.' Both painting and inscription convey the high regard in which Lord Exmouth was held as a popular hero. Edward Pellew had a distinguished career in the Royal Navy, in which he had first served as a midshipman at the age of 13. From the period of the American War of Independence, in which he first saw action, he was promoted through the ranks with exceptional speed, achieving the status of popular hero at the time of the Napoleonic Wars. His famous capture of the French frigate *La Verginia,* is celebrated in the painting on page 37 Rewarded for his courage and gallantry by being created first Viscount Exmouth in 1814, Edward Pellew is shown in his admiral's uniform with drawn sword against a schematic background of a country estate.

▷ **Tom Sayers, Prize Fighter**
Artist unknown

Oil on panel

TOM SAYERS (1826-65), at 5 ft 8 in and 155 pounds, was known as the 'Little Wonder' and the 'Napoleon of the Prize Ring'. He was the most famous English pugilist of his day, renowned for his courage and sportsmanship and for losing but one fight in his career. He often fought much larger and heavier opponents, as in his last, legendary fight against the American John C. Heenan in April 1860. Sayers was 40 pounds lighter and seven years older than Heenan but was made a 2-1 favourite. The fight was declared a draw after 42 rounds and championship belts were awarded to both boxers. On Sayers' retirement after this fight an unprecedentedly large public subscription of £3,000 was raised for him, a measure of his huge popularity. Here he is shown in profile in characteristic bare-knuckle pose. The painting is probably derived from the many popular sporting prints of Sayers readily available in the Victorian period.

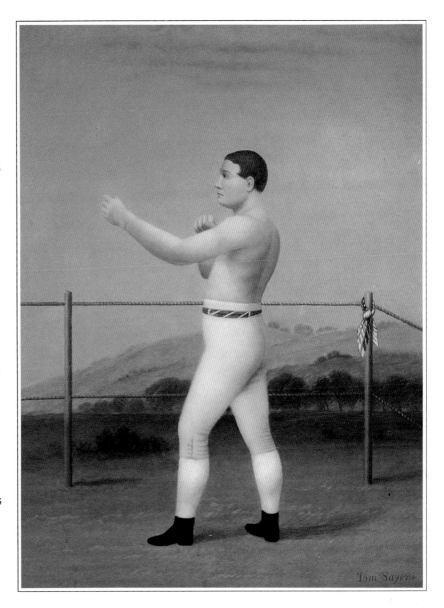

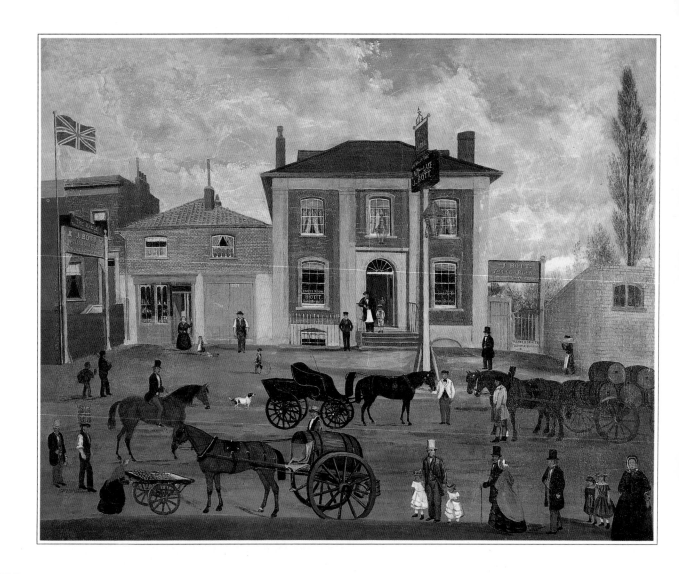

◁ **The Eagle** *or* **Lady of the Lake Inn** 1857 J. Chalmers

Oil on canvas

MANY STREET SCENES with prominent buildings, such as this busy west London slice of life from the middle of the 19th century, were probably conceived as documents of record. It is is possible in the case of this painting, for example, that the proprietor of the *Eagle*, J. Bott, whose name is prominently displayed no less than five times on sign boards in the painting, may have commissioned the work. Certainly the scene is crowded with incident, from the chimney-sweep and his boy on the left behind the costermongers to the fashionably dressed family groups in the foreground.

The horse traffic includes a brewer's dray about to make a delivery. The prominently placed tavern in the painting, *The Eagle* or *Lady of the Lake* (both names are clearly shown on the signboard), still exists, in a much altered state, in Fulham, west London, and is still called *The Eagle*.

In the Lion's Den c.1870 W. H. Rogers

Oil on canvas

▷ *Overleaf pages 42-43*

THIS IS A UNIQUE SUBJECT in naive painting. Lion-taming was a popular part of Victorian entertainment. The Dutch-American wild animal trainer Isaac van Amburgh was the first 'gentler' of wild animals. Queen Victoria was so enthusiastic about his performance at Drury Lane – 'one can never see it too often' – that she bought the picture painted by Sir Edwin Landseer (1802-73) in 1839 that depicts the famous trainer in Roman gladiator costume at ease with a lion, lioness, two leopards and a lamb. W. H. Rogers evokes memories of the popular engraving of Landseer's painting in this work, not least in the viewpoint, although his young tamer looks distinctly uneasy about the tigress licking his face and the large lion with its paw on the knee of his fashionable trousers. The three cubs are technically 'ligers', a breed known only in captivity. All the animals are painted in true naive style, engaging and haunting representations that transcend time and national boundaries, appearing as they do in the mid-19th century in Pennsylvania in the work of Edward Hicks, and in the late 19th century in Paris in the work of Henri Rousseau.

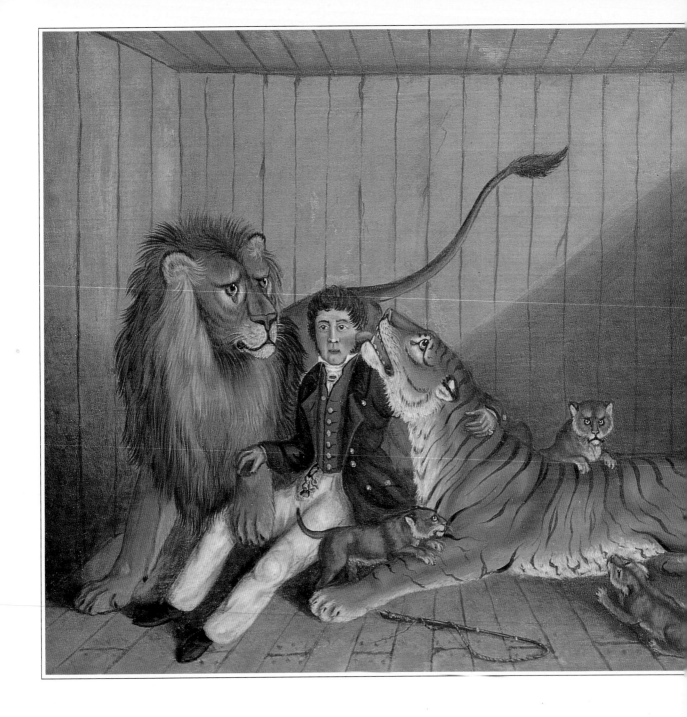

A Pair of Pigs c.1850
Artist unknown

Oil on canvas

▷ *Overleaf page 44*

THIS PAINTING is characteristic of a popular form of representation of farm animals which were often produced by itinerant painters and did not change much over a long period of time. Therefore the comments of Thomas Bewick (1753-1828), the celebrated English wood engraver of rural subjects, who objected to the way that sheep and cattle were represented in his time, are invaluable in considering such a painting as this: 'Many of the animals were during this *rage* for fat cattle fed up to as great a weight and bulk as it was possible for feeding to make them; but this was not enough; they were to be figured [represented] monstrously fat before the owners of them could be pleased. Painters were found who were quite subservient to this guidance and nothing else would satisfy.' Even when viewed in the light of Bewick's criticism these prize pigs would still appear to be 'monstrously fat'.

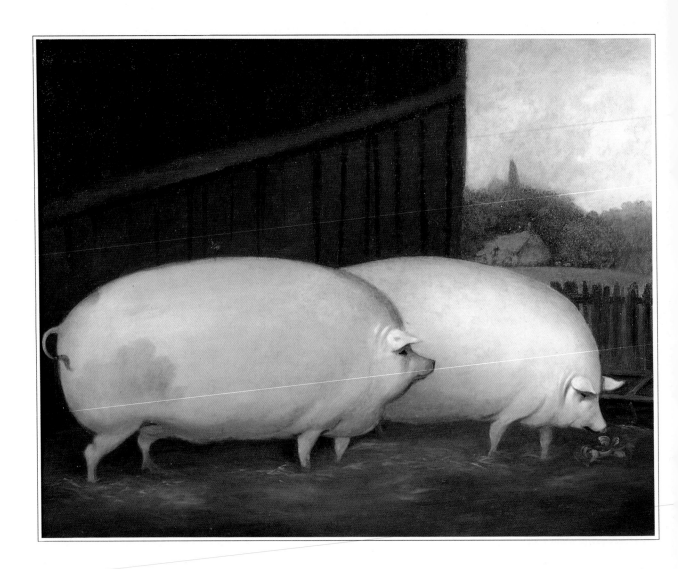

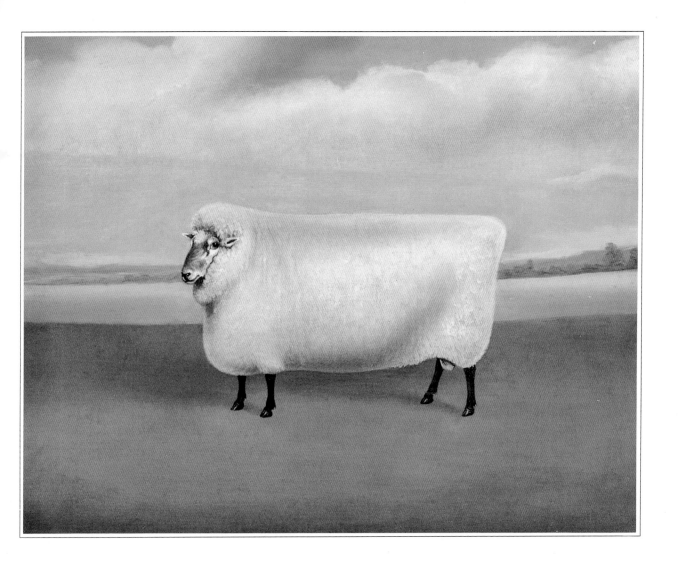

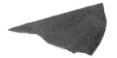

▷ **Midsummer Night's Dream** 1860
W. Balls

Oil on canvas

THE SUBJECT MATTER of this painting by W. Balls is almost wholly obscure, as is the life of the artist. The theme of the painting may derive from Shakespeare's play of the same title, in which case this would represent Titania, the Queen of the Fairies, and Oberon, her consort, together with the mischievous spirit Puck, or Robin Goodfellow, on the left. Such 'fairy subjects' were very popular in Victorian high art and in book and other illustration. However, in this painting the burning tree and the pet dog are not explicable in these terms, and it seems likely that the origins of the most prominent figures in this mysterious and magical painting lie in popular Victorian theatrical prints or the 'Penny plain, twopence coloured' card figures that were widely available in the period for use in children's toy theatres.

The Prize Ram c.1850 Artist unknown

Oil on canvas

◁ *Previous page 45*

THE RAM IN THIS PAINTING by an unknown artist working in England has a powerful and engaging presence. It is placed in the very centre of the picture space, between earth and sky, and at a fair distance from the spectator, whom it regards with a watchful eye. The ram's splendid fleece does not reflect the light, and the simple yet effective design of the whole image has an iconic power that is impossible to quantify but immediate in its impact. As to its huge size and luxuriant wool, it appears that many prize animals such as this were bred and fed to look very much like their painted representations. Indeed, some Victorian animals were so fat that their legs became unable to bear their weight and they had to be propped up with timber supports. This prize ram, however, almost rectangular in shape, stands four-square on elegant legs that seem perfectly able to support its extraordinary proportions.

▷ **Master George** 1870 Artist unknown

Oil on canvas

THIS PAINTING is inscribed at the bottom 'Master George, 12 hands high, finishing his mile in 2.55, completing the 2 miles in 5.58½, August 1870.' The signpost past which Master George speeds so fast is inscribed 'To London 19 miles Brentwood 1.' It is possible that the painting commemorates Master George's feat in what was known as a match against time: a subject that was sometimes recorded in contemporary paintings and prints. The match against time was, as the words suggest, a race against the clock rather than another horse or horses, and was, more often than not, done for a bet. Horses and horse subjects, including racing animals, were as popular a theme for folkpainters in England as such subjects have always been in other forms of art.

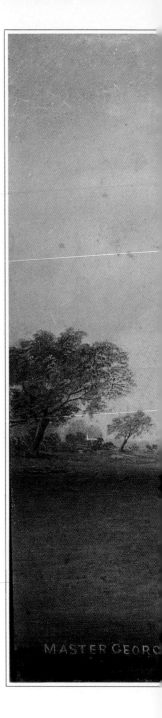

MASTER GEORG

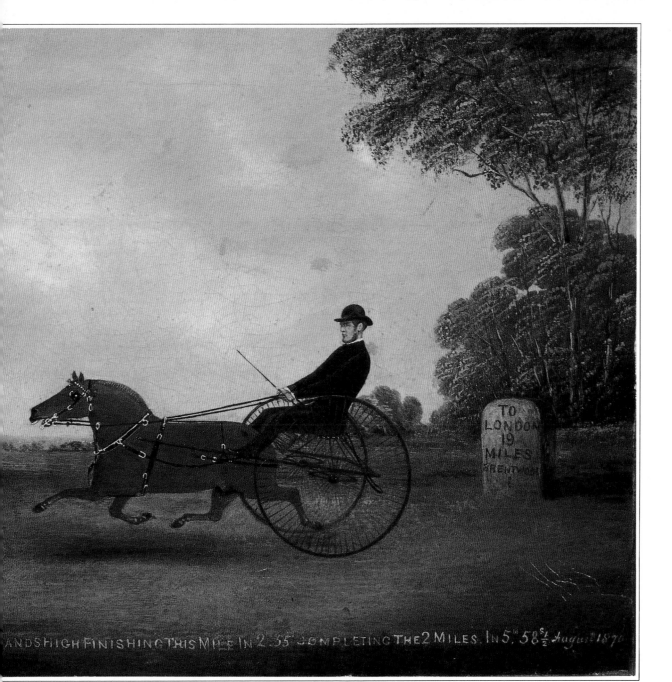

...ANDS HIGH FINISHING THIS MILE IN 2.55 COMPLETING THE 2 MILES IN 5.58½ August 1870

A Prize Bull and a Prize Cabbage Artist unknown

Oil on panel

◁ *Previous pages 50-51*

THIS PAINTING can be dated from the very first years of the 19th century, it was probably painted by an itinerant painter named Williams in 1802. Like other animal paintings in the British Folk Art Collection in Bath reproduced in this book, it represents its subject in profile. This device is typical of naive painting as it shows the finer points of the animal and it is technically less difficult to paint in this manner. In this respect it can be compared to such contemporary American paintings of livestock as Edward Hicks' *The Cornell Farm* and Amsi Emmons Zeliff's *The Barnyard*. This painting is however unique in the fact that alongside the animals is a portrait of the farmer's wife proudly displaying a fine cabbage which she holds carefully by its stalk.

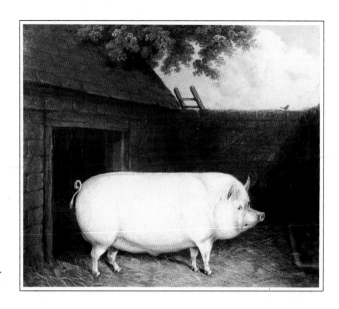

△ **A Pig in Its Sty** E. M. Fox

THIS PAINTING by the Victorian artist E. M. Fox, about whom nothing is known, is characteristic of a particular genre of animal painting popular in both Europe and America in the 19th century. It may have been commissioned by the farmer who bred such a fine specimen, and may have been intended as a document of record or as a hoped-for ideal! Painters who earned their livings in other fields, as sign or coach painters, for example, were often commissioned for such a purpose. These images would sometimes have achieved greater circulation by being reproduced as popular engravings. This sagacious-looking pig is accompanied by a larger-than-lifesize robin perched on the wall of its sty.

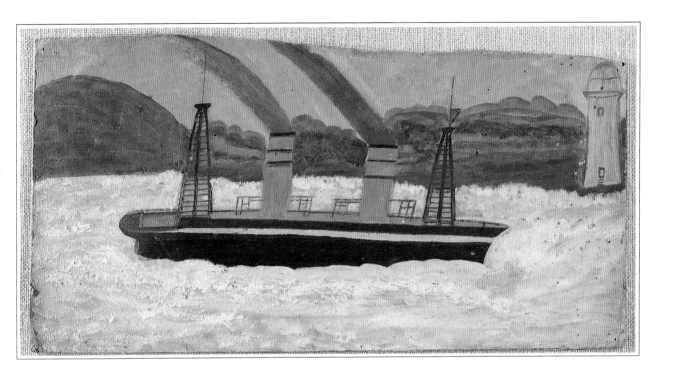

△ **The Steamer** Alfred Wallis (1855-1942)

Ships' paint on cardboard

ALFRED WALLIS had gone to sea at the age of nine as a ship's cabin-boy and cook, and later had worked as a fisherman in Cornwall. He opened a rag-and-bone or scrap metal shop in St Ives in 1890, and lived in Cornwall for the rest of his life. . He began painting in 1922 to relieve his loneliness after his wife died. Wallis worked from memory and from his imagination, producing such forceful and distinctive images as those shown here. Wallis's work was discovered by the artists Ben Nicholson and Christopher Wood in 1928, and influenced their own to a marked degree. However, although he quickly became the best known of all British naive artists and his work was bought by national collections, he died in a poorhouse in 1942 suffering from senile paranoia.

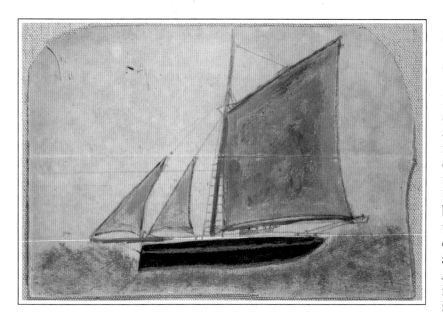

△ **The Yacht** Alfred Wallis

Ships' paint on cardboard

WALLIS PAINTED HIS MEMORIES of experiences rather than from direct observation. He described his views of St Ives, where he lived, in the following terms: 'I do most what used to be what we shall see no more every thing is altered.' Wallis's vision and his vigorous feeling for rhythm and colour, as well as his rejection of conventional one-point perspective, convey, particularly in his sea paintings, a feeling of escape and freedom. Wallis' technique was also unconventional. He painted with ships' colours on odd bits of wood or pieces of cardboard boxes given to him by the grocer next door, incorporating the brown, grey or green board and the distinctive texture into his powerful and striking compositions.

▷ **The Pond** Laurence Stephen Lowry (1887-1976)

Oil on canvas

L.S. LOWRY lived and worked all his life in or near Salford and Manchester. He retired from work as a clerk and rent collector in 1952, and until then painted only after work. Like many other artists in this book, Lowry was not untrained, attending art classes intermittently from about 1905 until l925. *The Pond* is quintessential Lowry in its high viewpoint and its industrial landscape crowded with people, who are, as Lowry explained, lonely: 'All my people are lonely. Crowds are the most lonely thing of all. Everyone is a stranger to everyone else. You have only got to look at them to see that.'

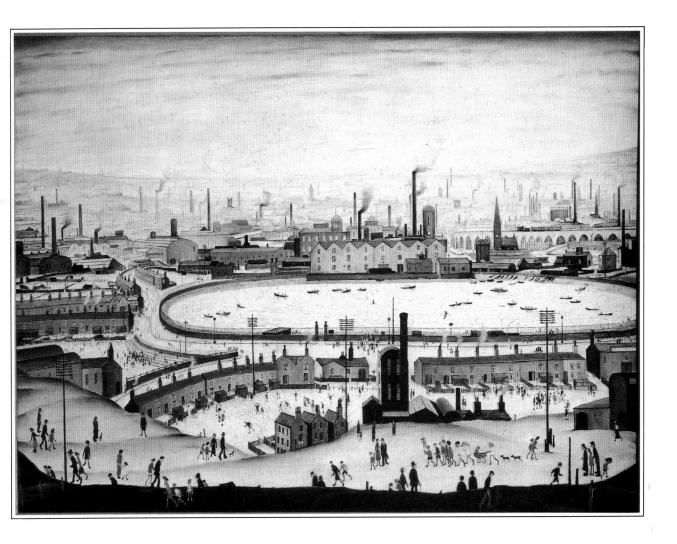

▷ **The Bandstand** L.S. Lowry

Oil on canvas

LOWRY LED A SOLITARY LIFE, explaining 'Had I not been lonely I should not have seen what I did.' Here the crowds converging around the bandstand appear to be dancing and enjoying the music, although the stick-like figures are dwarfed by the industrial buildings in the bleak landscape. Characteristically, they are seen from a bird's-eye view at a great distance, a device Lowry frequently used to convey his belief that 'the thing about painting is that there should be no sentiment. No sentiment.' Lowry divided critical opinion in his time, although his work always had a popular appeal; since the Royal Academy exhibition in London in the year of his death, his paintings have been undergoing a process of re-evaluation.

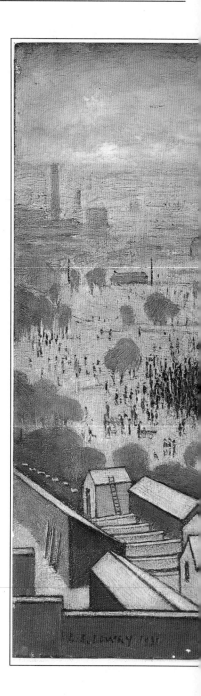

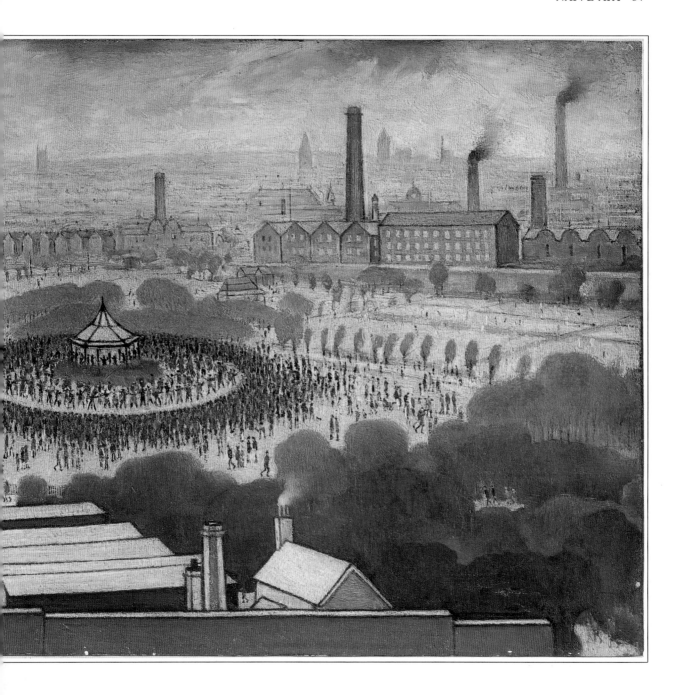

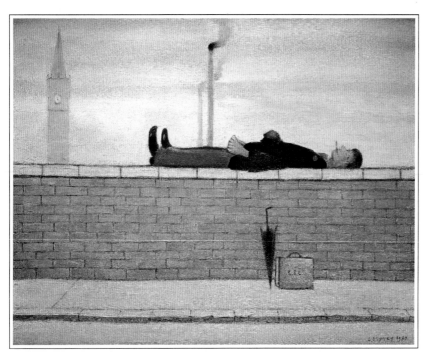

◁ **Man Lying on a Wall** 1957
L.S. Lowry

Oil on canvas

LOWRY WAS A keen observer of people and often recorded interesting and amusing incidents as he went about his everyday life. This close-up representation of a single figure is unusual in his work. He commented at the time that 'I saw it from the bus in East Lancashire and thank goodness the bus stopped long enough for me to get a good look at the man. He didn't mind, he was enjoying his rest. Isn't that amazing?' Lowry added 'Why shouldn't a serious painting be funny and still be taken seriously?', and put his own initials to the man's briefcase.

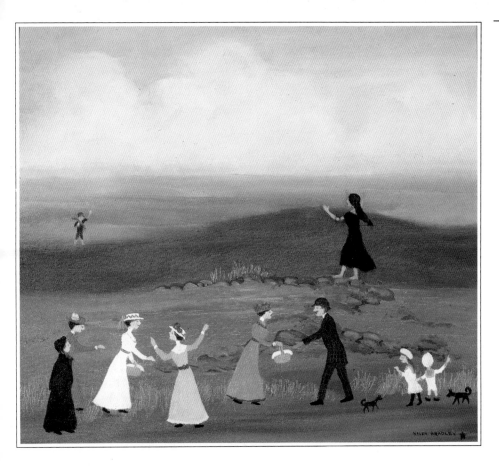

△ **Adam and Eve: the Picnic** Helen Bradley (1900-79)

Oil on board

HELEN BRADLEY WAS BORN and brought up in Lees, on the outskirts of Oldham, Lancashire, and did not begin to paint until she was 65. She did so then, with a unique and childlike 'eye' that is wholly distinctive, in order to provide images of her own childhood for her grandchildren. There is a strong narrative element in all her work, a story telling dimension that is evident in the often long and complex titles to her paintings. The publication of of her semi-autobiographical paintings and stories, *And Miss Carter Wore Pink: Scenes from an Edwardian Childhood,* in 1971, and its sequels, *Miss Carter Came with Us* and *In the Beginning Said Aunt Jane* brought her work to a huge and devoted public in Britain and the United States.

▷ **Oh look what has happened! Those bulls did get loose!** Helen Bradley

Oil on board

THIS PAINTING IS TAKEN from Bradley's book *And Miss Carter Wore Pink*, which relates, in Helen Bradley's words, 'a love story of that gentle period', the loves of her three maiden aunts and their friend next door, Miss Carter (who wore pink) and Mr Taylor, the bank manager. They all can be seen in most of her paintings; Miss Carter is particularly distinctive. Bradley's particular gift was to be able to represent her acute memories of childhood almost as a child remembers and to paint almost as a young child paints. The title of this painting is indicative of this quality, as is this memory of the days of her childhood: 'Even the sun shone when it was supposed to and the snow came just at the right time and life moved gently onwards.'

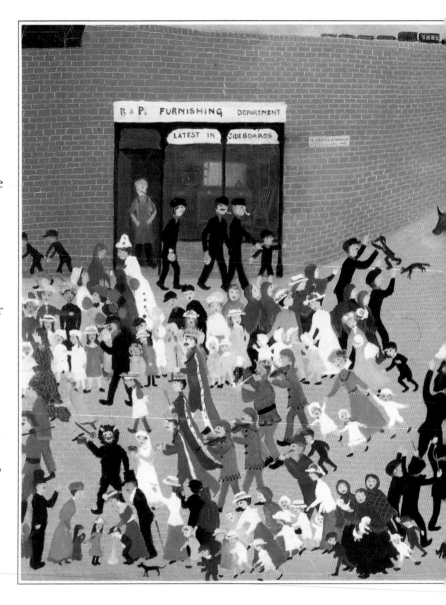

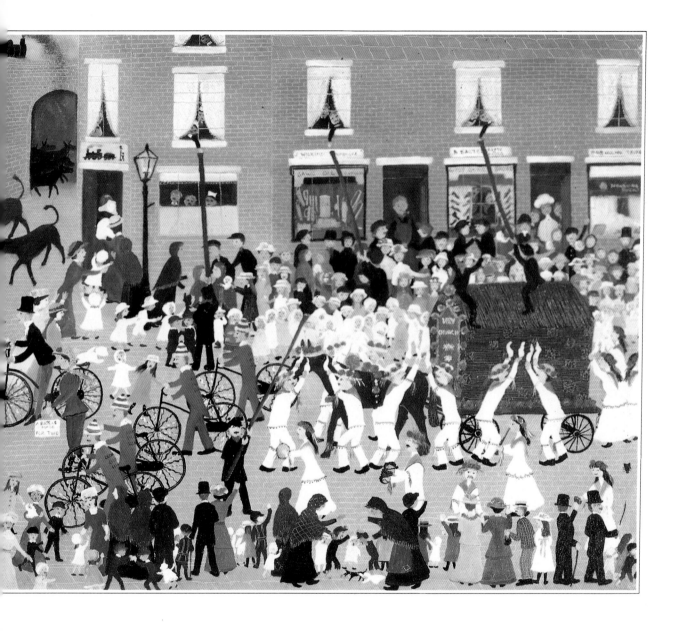

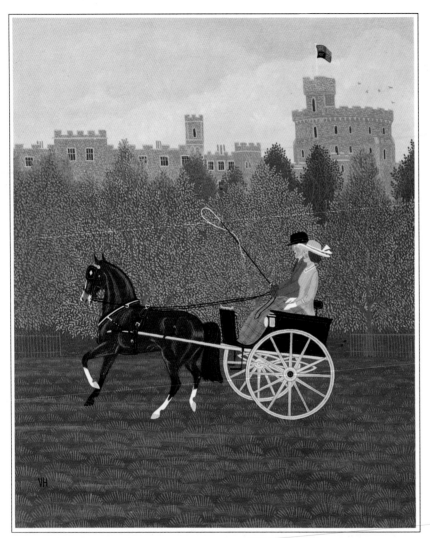

◁ **Riding in the Carriage Past the Castle** Vincent Haddelsey

Oil on canvas

BORN IN LINCOLNSHIRE and educated at Ampleforth, Yorkshire, Vincent Haddelsey taught himself to draw with a mapping pen at a very early age, and is entirely self-taught as a painter, completing his first oil at the age of eight. His knowledge of horses began in his childhood, on the family farms and in the hunting field. Since then he has always been involved with various activities concerning horses and their history. In 1978 *Haddelsey's Horses*, a book of his paintings, recording his involvement in every form of sporting activity to do with horses, including polo, showjumping and racing was published. Here his equestrian subject is placed in front of Windsor Castle.

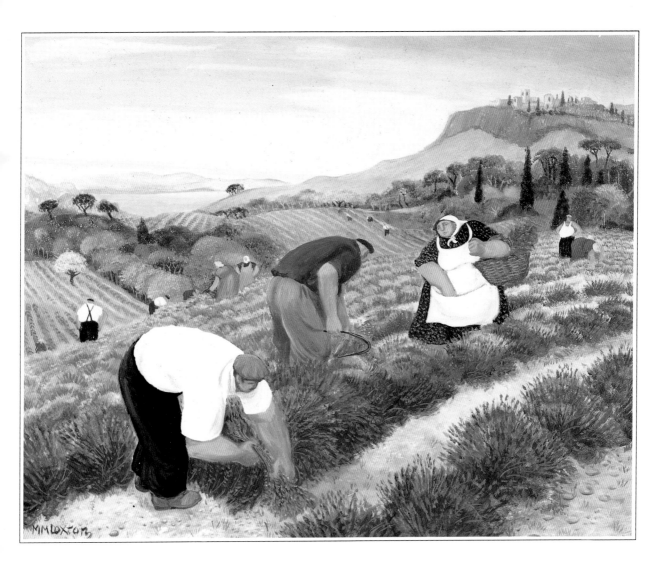

▷ **Harvest Scene** Mirko Virius (1889-1943)

THE WORK OF THE Croatian painter Mirko Virius is remarkable for its powerful social realism, drawn from his own hard experience and meagre existence on the land. Virius spent several years as a young man in a Russian prisoner-of-war camp. When he returned from captivity he began to paint scenes of village life he had recalled and been able to draw while still a prisoner far from home. He came under the influence of two other Croatian painters, Ivan Generalic and Franjo Mraz (b.1910), and the three became known as the Hlebine Trio. In the painting reproduced here Virius shows his knowledge of the harshness of rural life and of the unremitting toil of the workers on the land. The subtle and muted colour range serves only to enhance the sense of toil conveyed by the figures and the ways in which their lives are bound to the land. The personal experience of the artist for his subject is starkly conveyed and deeply felt.

Lavender Margaret Loxton (b.1938)

Oil on canvas

◁ *Previous page 63*

THE BRITISH PAINTER Margaret Loxton was born just before the Second World War and attended ten schools. Her formal art college training proved abortive, lasting only three months, and she has struggled to find her unique style, feeling free to paint in her present manner only after her divorce in 1981. Her subject matter includes scenes from British agricultural life and Cornish fishing scenes as well as similarly down-to-earth representations of peasant life in France, such as this painting of the timeless labour of lavender gathering.

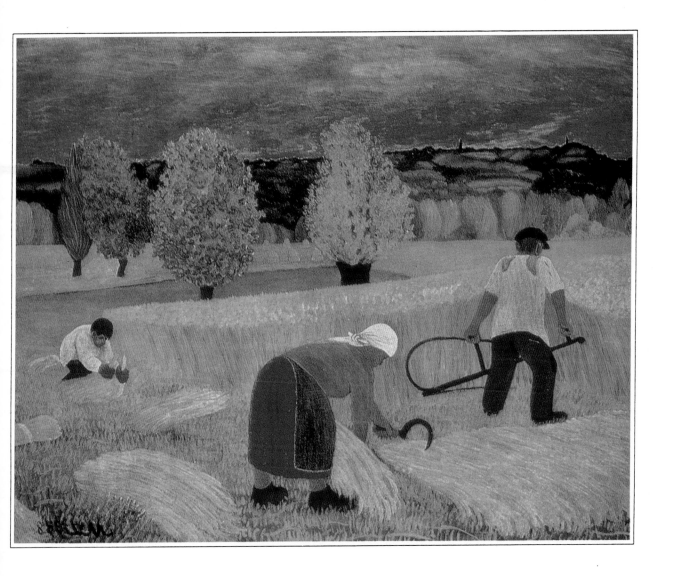

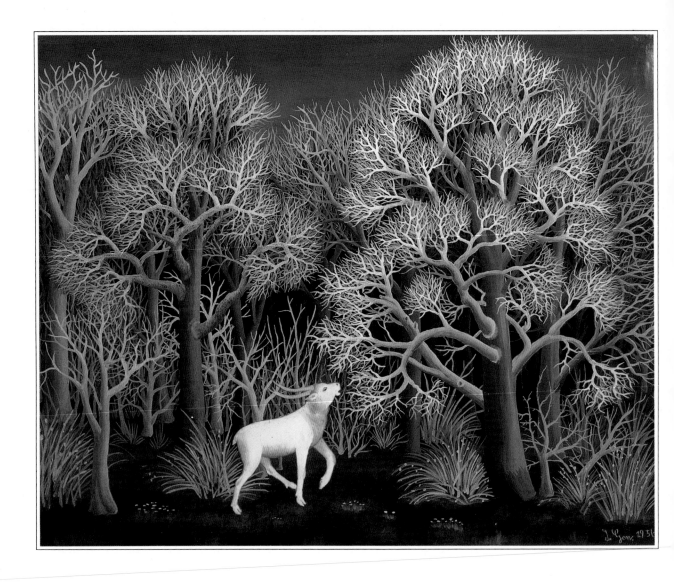

◁ Stag in the Forest Ivan Generalic (b.1914)

IVAN GENERALIC has spent most of his life in the village of Hlebine, close to the Hungarian border. From a peasant family, Generalic first came to fame in 1931 in an exhibition with his fellow painters Mirko Virius and Franjo Mraz, in which he exhibited scenes of rural life inspired by the social injustices of the time. This moonlight scene is characteristic of Generalic's distinctive style, with its subtle range of tones and dream-like visionary quality. Generalic has become the best known Croatian painter of his generation. His visionary work is exhibited and collected worldwide and he has been the teacher and inspiration for a new generation of naive painters in his native country.

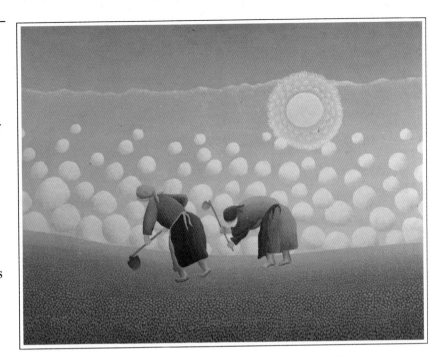

△ Women Digging Ivan Rabuzin (b.1921)

BORN IN KLJUC, CROATIA, Ivan Rabuzin was originally apprenticed as a carpenter, and this precise and logical training can be seen in the geometrical framework and harmonious form of his paintings He is one of the best known naive painters of Croatia, distinguished both in his native country and abroad. His work is remarkable for its order and serenity, as can be seen in this painting, which is unusual in Rabuzin's work in that it contains more than one figure. Here the women digging are engaged in a timeless activity. The artist has explained: 'In my pictures, I beautify nature. In other words, in nature I create an order that suits me, I create a world that pleases me and that appears the way I want it to.'

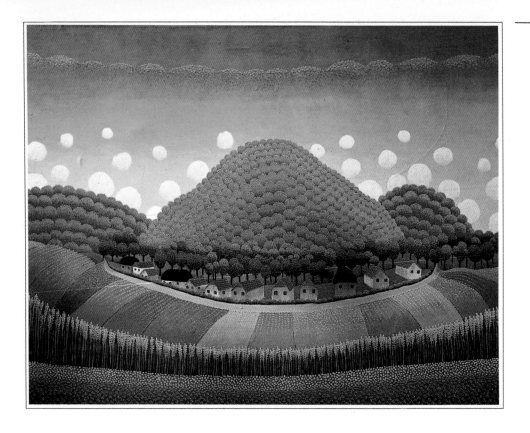

△ **Magic Village in the Mountain** Ivan Rabuzin

IN RABUZIN'S HARMONIOUS, optimistic world there are seldom figures at work, although the results of good agricultural management are to be seen in the well-ordered crops and thick trees of the wooded hillsides. The idyllic countryside is drawn from that of his birthplace, which he represents as little changed since he was a child. Rabuzin comments on his childhood fantasy of a perfect world, which he likens to a glass globe 'which would contain everything without exception and warm sun rays [would shine]', a toy that seems particularly relevant to this painting. In *Magic Village in the Mountain* the tree studded hills and symmetrically planted fields are safely contained within just such a globe-like form.

▷ **Village of My Dreams** 1966
Ivan Rabuzin

RABUZIN'S CAREER is generally
considered to have reached a
turning point in the early
1960s, and the growing
maturity and unique style of
his work, together with
frequent exhibitions, ensured
recognition both at home and
abroad. In this painting
Rabuzin elaborates on the
constant theme of his work,
that of the perfect idyllic rural
world, unchanged by modern
technology. The artist writes:'
The world I see must be
changed; things must be set
and reset in it to be in good
order, to make a garden to
satisfy mankind.' Here once
again he expresses his
childhood dream of putting
the sun, fields and village
under a glass cupola, which
appears to be encircled by a
dream-like arch and have
great white circular forms like
cotton on the inner side to
further protect the 'dream
space'.

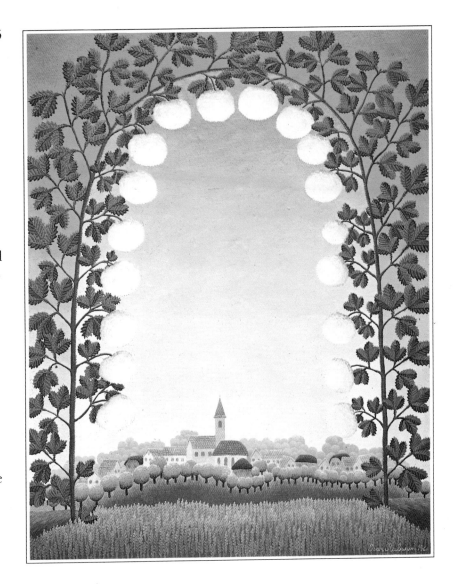

▷ **The City Built Like a Ship** Dregutin Jurak (b.1911)

DREGUTIN JURAK was born in Pusica, Croatia. He had no formal schooling but began work as a carpenter's assistant, making scenery for the Croatian National Theatre. The influence of stage constructions can be seen in his work, and he is best known for the unique and extraordinarily fantastic structures that he began painting in 1960. *The City Built Like a Ship* is a fine example of Jurak's work at its most characteristic, with its decorative ironwork, intricate carving and exotic foliage. It represents, in Jurak's words, 'everything our seamen would have seen as they wandered the earth and stopped at the big ports of the world, things they told me about.'

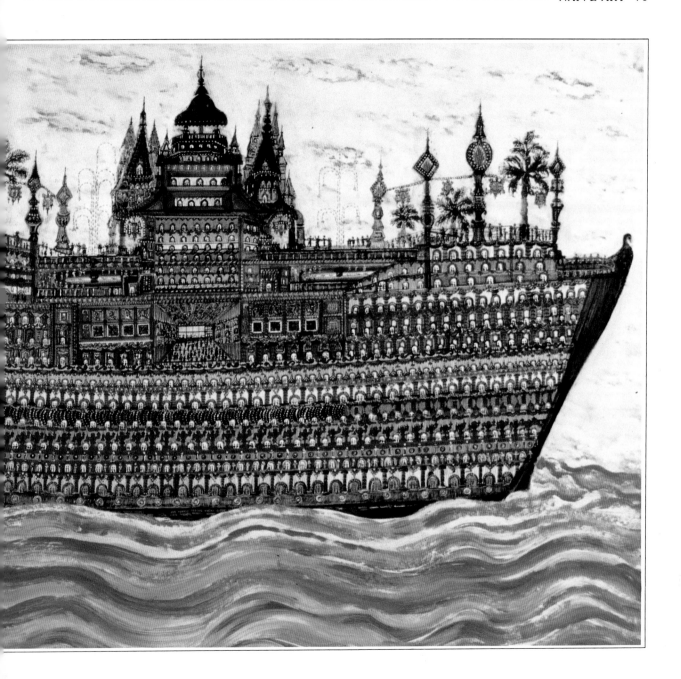

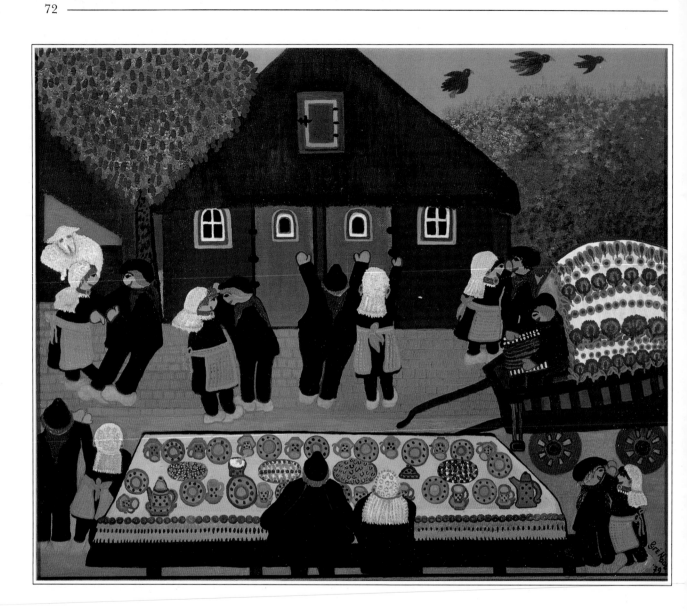

◁ **The Harvest Feast**
Gré Noot (b.1914)

GRÉ NOOT was born in
Enschede, in the Netherlands.
She did not begin to paint
until she was given a box of
painting equipment when she
retired from her job as the
head of the service section of a
large hotel, where she had
worked while bringing up the
five children of her first
marriage. Her daughter, who
is a sculptor, suggested that
Noot might take painting
lessons, and in 1970 Noot had
a one-woman exhibition of
watercolours, gouaches and
oils at Zwolle. She paints in
bold colours, with a strong
sense of design. A frequent
theme of her work is local folk
customs, as is demonstrated in
The Harvest Feast. The subject is
taken from her youth, 'the
happiest time of my life'.

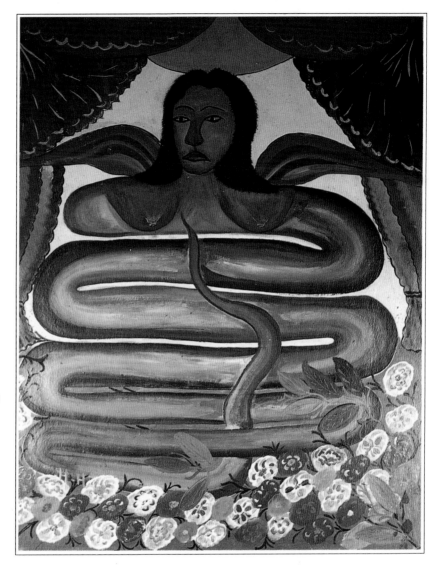

▷ **National Procession**
Seneque Obin (1893-1977)

SENEQUE OBIN was the younger brother of Philomé Obin, who, together with Hector Hyppolite, is one of the founding fathers of Haitian naive painting. Seneque began his career as a coffee merchant, but began to paint in 1948, encouraged by his brother, from whom he received instruction. The work of the two brothers has points in common, not least the representation of themes from Haitian life and culture. However, Seneque's work is distinguished by its use of a wider range of subject matter and particularly by its greater use of black. In this painting a funeral procession is depicted and celebrated in Seneque's characteristically energetic and vivid style, in a flattened perspective typical of the work of both brothers.

Dambalah La Flambeau Hector Hyppolite (1894-1948)

◁ *Previous page 73*

HECTOR HYPPOLITE was apprenticed as a shoemaker, worked as a *hungan* (voodoo priest) and is generally regarded as one of the founding fathers of the Haitian naive school of painting. Hyppolite was encouraged in his painting by the Cuban painter WIlfredo Lam, and through him by the influential French poet and critic André Bréton. Breton and other major Surrealist artists and thinkers made Hyppolite's work known to a wide audience in Europe and the United States through exhibitions and reviews. In this painting, a work that is essentially rooted in Haitian culture, religion and folklore, Hyppolite uses a range of dark tones and colours characteristically to conjure up a mysterious and magical rite.

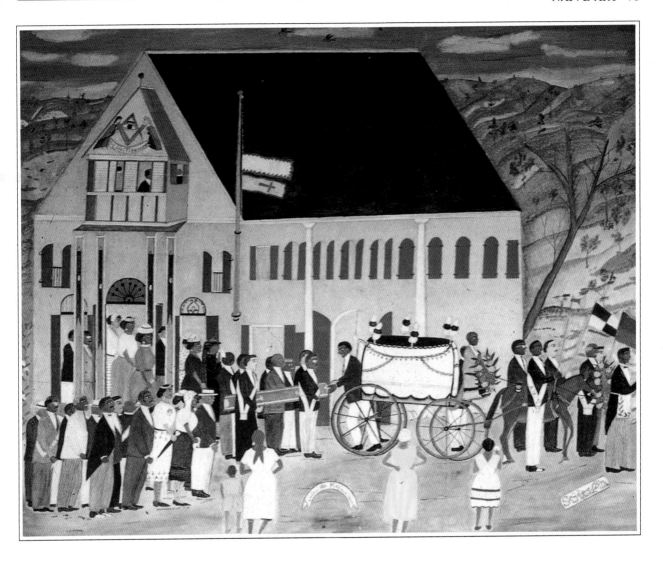

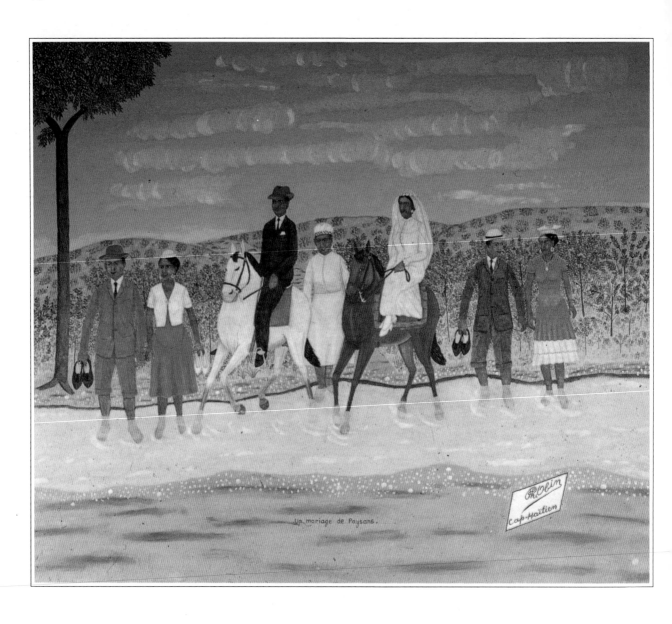

Un mariage de Paysans.

Ph.Olin
Cap-Haïtien

◁ **Peasant Wedding** Philomé Obin (1892-1977)

PHILOMÉ OBIN, together with Hector Hyppolite, is generally regarded as one of the founding fathers of Haitian naive painting. However, the subject matter and approach to their work of both painters (who were friends) could not have been more different. In radical opposition to Hyppolite's dark world of fantasy, Obin's work represents the historic events of his homeland on a large scale in a complex and rational ordering of large numbers of figures. Many of his paintings, such as this one, also show important ceremonial occasions in the lives of his contemporaries. The wedding party, with the bride and groom on horseback, is painted in Philomé's characteristically meticulous detail and with his accustomed luminous colours and sense of order.

▷ **Woman Selling Fruit** 1959 Castera Bazile

THE HAITIAN PAINTER Castera Bazile first worked as a house servant and messenger at the Art Centre at Port au Prince. He received instruction and began to paint in 1945. Ten years later he was commissioned to paint three enormous wall paintings for Holy Trinity Church in Port au Prince. In *Woman Selling Fruit* Bazile depicts a market woman at her stall with a basket of splendid fruit in his characteristically powerful manner and bright clear colour.. The woman and the fruit are reduced to their essential forms in a bold, stylized manner. The design fills the entire picture space and, indeed, seems almost to burst out of the frame.

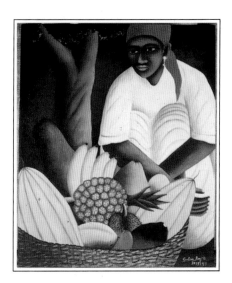

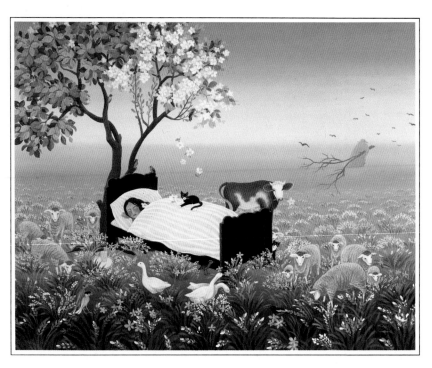

◁ **Lena's Dream** 1987
Magdolina Bân (b.1940)

Oil on canvas

MUCH OF MAGDOLINA BAN'S work is based on experiences of her childhood in Hungary. Later, she worked as a photographic reporter and for the magazine *Musica* before leaving Hungary, and at a low point in her life found her way 'to my first passion – painting'. To her childhood memories of Hungary she added clear colours and surreal symbolism without omitting any of the former idyllic 'Hungarian quality'. She painted *Lena's Dream* after her daughter phoned her from New York City, 'informing me of a repeated nightmare she had, featuring a big dark menacing man. To charm away the evil menace of this dream I painted Lena in an idyllic setting with all her familiar things around keeping her from harm.' Bân now lives in Lucerne. She has exhibited widely in Europe, the United States, Australia and Japan, and is a recipient of the illustrious Prix International Suisse de Peinture Naive, among numerous other awards for her work.

ACKNOWLEDGEMENTS

The publisher would like to thank the following for their kind permission to reproduce the paintings in this book:

Bridgeman Art Library, London: 16-17; /**Christie's, London**: 9; /**Philadelphia Museum of Art, Pennsylvania**: 10-11; /**Private Collection**: 12-13, 20-21, 22-23, 26, 27, 62, 65, 68, 69, 72, 73, 75, 76, 77, 78 (*also used on front cover, back cover detail and half-title page detail*); /**Newark Museum, New Jersey**: 14-15; /**National Gallery of Art, Washington DC**: 18-19; /**Whitney Museum of American Art, New York**: 24-25; /**Courtauld Institute Galleries, University of London**: 32; /**Hermitage, St. Petersburg**: 33; /**Narodni Galerie, Prague**: 35; /**Bonhams, London**: 52, 59, 60-61; /**Towner Art Gallery, Eastbourne**: 53; /**John Davies Fine Paintings, Stow-on-the-Wold, Glos.**: 54; /**Tate Gallery, London**: 55; /**York City Art Gallery**: 56-57; /**Salford Museum & Art Gallery, Lancs.**: 58; /**RONA Gallery, London**: 63; /**Gallery of Primitive Art, Zagreb**: 66, 67, 70-71

Phillips Collection: 29

Galerie St. Etienne: 30-31

Naïve Museum: 36-37, 38, 39, 40, 42, 44, 45, 47, 48-49, 50-51

NB: Numbers shown in italics indicate a picture detail.

Every effort has been made to trace the copyright holders and we apologise in advance for any unintentional omissions. We would be pleased to insert the appropriate acknowledgement in any subsequent edition of this publication.